STAATLICHE MUSEEN

PREUSSISCHER KULTURBESITZ BERLIN

ÄGYPTISCHES MUSEUM

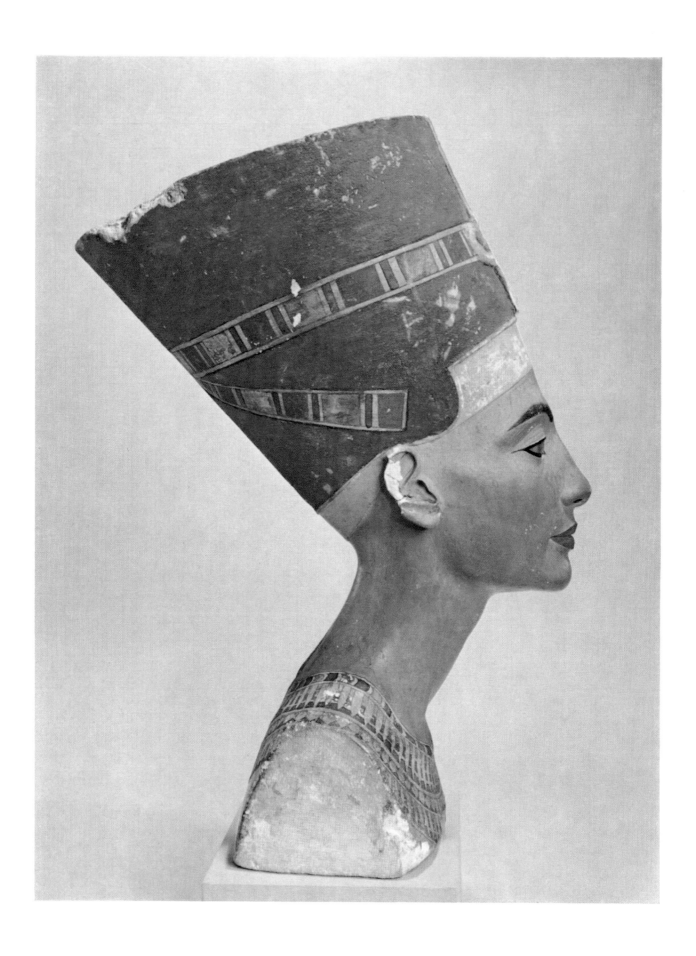

RUDOLF ANTHES

THE HEAD OF QUEEN NOFRETETE

Gebr. MANN VERLAG · BERLIN

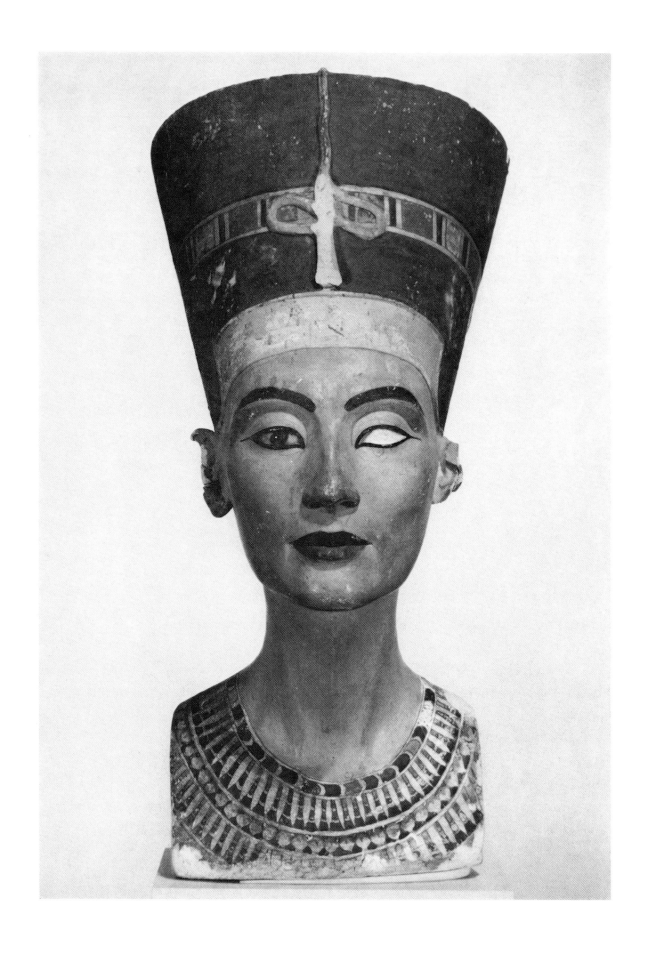

The head of the Egyptian Queen Nefertiti (Nofret Ete) dates from the reign of her husband, King Amenophis IV – Akhenaton (1364–1347 B.C.), who ruled during the XVIII dynasty of the New Kingdom.

The head was found in Amarna in December 1912 in the excavations conducted there by Ludwig Borchardt on behalf of the Deutsche Orient-Gesellschaft and financed by Dr. James Simon, one of the founders of that society. Under the agreement with Egypt on the division of the treasures found in the excavations, James Simon obtained the head which he presented, together with other finds from the excavations, to the Egyptian Department of the Berlin State Museum in 1920.

The head is 48 cm high and the base at the front is 19.5 cm broad. The portrait is fashioned from a fairly soft limestone, supplemented by plaster. It is painted, only the lower sectional areas at the sides and the eye-sockets being uncoloured. The Queen is wearing the type of blue crown, levelled off at the top, which is well-nigh peculiar to her, having only very seldom been previously seen in certain likenesses of Queen Teje. The band twined around the crown is intended to be of gold and semi-precious stones, and the headband is of gold. The royal serpent has been broken off. At the nape of the neck hang two ribbed red ribbons. The eyebrows and the rims of the eyelids are painted, the pupils made of a shell of rock crystal, on the reverse of which a shallow layer of black colour has been imposed. The limestone background of the eye-socket shines through and so acts as the white of the eye. Across the eyelid runs a finely chiselled line. The lips are painted red, the collar matches the colour of the semi-precious stones and the gold, and the remainder is of a light reddish-yellow skin tone. The shoulders are cut off vertically. The fact that the head was meant to serve as a studio model probably explains why it was only thought necessary to insert one eye.

Damage to the head is but slight. Pieces have been broken from both ears, and in some places the surface of the crown has cracked and broken off. Of the writhing viper, the uraeus, the royal emblem which rears itself above the forehead, only the hind portion and the tail remain. The forepart and head were perhaps of plaster. All this damage, with the exception of the restored pieces on the ears, certainly occurred in antiquity, before the head was put aside in Thutmose's storeroom, since no further broken pieces were found there, in spite of a very careful search.

The following details of the dress are recognisable. The collar of stones and gold is in the form of a double wreath of petals: The headdress consists of the golden headband of a hairnet which is tied at the back with the dangling ribbons. Above that is a superstructure, which is perhaps a wig, but which, as a sign of royalty, may also been called a crown. Half way up it is held by a golden band, with coloured inlay, on which the uraeus rears itself. The hollows in the lobes of the ears are evidence of the heavy earrings which were fashionable at that time.

Ludwig Borchardt has made known the findings of an analytical chemist on the colours used for the head (Portrait of Queen Nofretete, Leipzig 1923, p. 32).
Blue: powdered frit, coloured with copper oxide,
flesh colour (light red): fine powdered lime spar, coloured pink by means of evenly distributed red chalk (iron oxide),
yellow: orpiment (arsenic sulphide),
green: powdered frit, coloured with copper and iron oxide,
black: coal with wax as a binding medium,
white: chalk (calcium carbonate).

Certain other technical details may be found in an account by the sculptor Richard Jenner, who years ago made for himself a copy of the head, and as result of his careful observations was asked by the museum to put these into writing. As it was neither possible to ask the author to revise the text nor obtain his permission for publication, the original wording is given here as evidence of the findings.
"In 1925 when I began the copy and the restoration of the ears and the uraeus, I soon observed in certain details a lack of form which was very obvious and difficult to understand in such a masterpiece, were it of stone. Ludwig Borchardt (Portrait of Queen Nofretete, p. 32) had already defined the missing piece on the left side of the wig as a 'largish layer of the plaster coating', and in particular the very uneven and almost wrinkled appearance of the wig's surface seemed to indicate it could not be of stone. While working in front of the original I discovered at the broken edges two different shades, which in places, and not only at the broken edges, are separated by fine visible cracks. Thereupon, with the consent of the administration of the Egyptian Department and under its supervision, I examined these broken places with the following results.
Where the broken patches occur at the upper edge of the wig, half right and half left towards the back, the layer of stucco is on an average 2 cm thick and forms a lateral coating, which, as the above mentioned place on the wig over the left ear shows, diminishes in thickness towards the neck, face and ears, and at these points forms only the necessary foundation for the painting. The already mentioned visible fracture, above the left ear, still shows chisel marks, which were intended to roughen the stone surface to ensure the better adherence of the stucco. The ears, so finely formed and delineated, the top surface of the wig with the serpent's tail

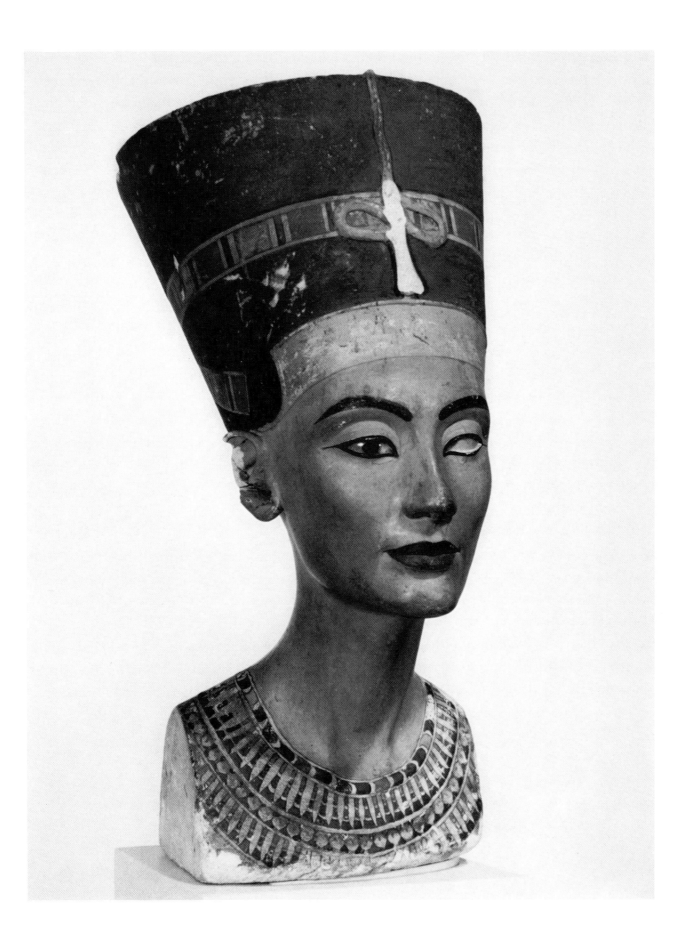

lying upon it, and the remains of the uraeus emblem in the centre of the headband, are of stone. On the sectional area of the shoulders the broken edges, right front and left back, show clearly an imposed layer of an average thickness of 1 cm which covers the breast, shoulders and back and thins out again towards the neck, which is indicated by the latter's chiselled form. A fine mark, which in some places at the sectional areas follows the contact line of stucco and stone, shows however that the apparent stone foundation of shoulder, breast and back has been hollowed out and filled with stucco, and a careful examination has proved this to be a fact. The side grooves, however, do not go through from shoulder to shoulder at the bottom, since stone was shown to be present when a hole was being bored to fasten the bust to the wooden block on which it now stands. It was not possible to make any investigations on the face or neck since, apart from fine cracks in the coating of colour, there was no damage which would have justified any such operation. Apart from the different degrees of hardness between stucco and stone, a variation was apparent to me in the plaster itself. Probably in some places, according to the use to which it was put, the plaster was mixed with ground limestone.

The sculptor and originator of the bust was apparently chiefly concerned with the finer points of the portrait, such as face, ears, uraeus and neck (which, as the stone supporting pillar, must in no way be weakened), since he wrought these technically most difficult portions finely in stone and treated all else as of secondary importance. This tendency is characteristic of the high level of plastic art and only thus can such works be understood. Perhaps it was intended to lessen the weight of the head and relieve the very slender neck by means of the comparatively solid subsequent stucco covering of the wig. (Weight of plaster 1,000 kilos per cubic metre, of limestone 2,500 kilos per cubic metre.)

Stucco or plaster served the artist as the necessary foundation for the colouring, and at the same time permitted corrections to be made in the face, and by allowing for retouching, made possible the speedier completion of a model head. Thus our investigation confirmed that L. Borchardt was right in his assumption that the bust was a model."

To Mr. Jenner's concluding remarks must be added that we have since come across stone sculptures in Egypt which were completed with plaster in the manner described above and which had left the studio and were in ceremonial use.

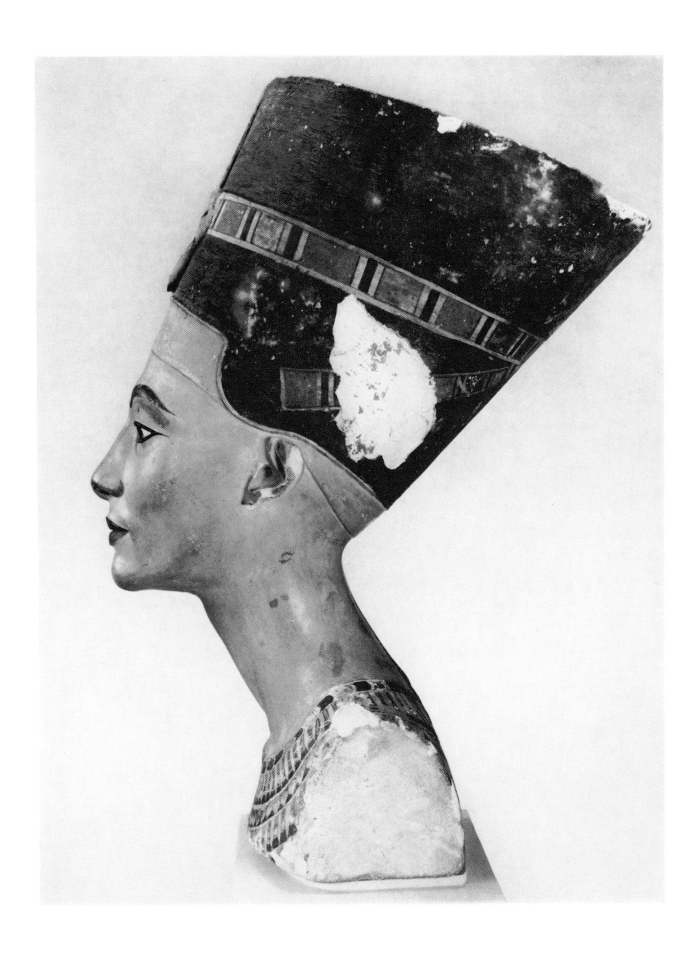

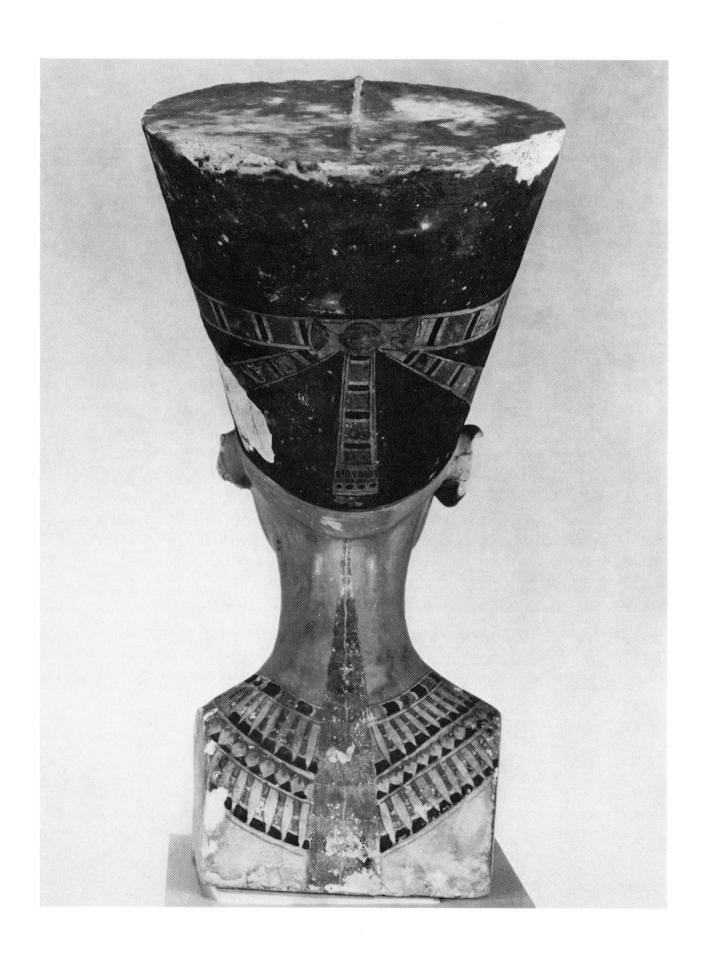

AN ESSAY IN CONTEMPLATION OF THE NOFRETETE HEAD

As with every portrait, the bust attracts the immediate interest of the discerning observer. But whether it appeals to him or not, in most cases a feeling of strangeness remains. That is small wonder, since the bust comes from a strange land and another age. It is hoped that the following lines will help to overcome this sense of the unfamiliar. They are based on practical knowledge of the Nofret Ete bust and her visitors in the museum, but they are not, and are not intended to be, more than a personal word on questions of art. Here, in the analysis of this work of art, a final judgment cannot be found, but only be acquired through continual contemplation of the bust, that is, through one's own efforts.

What strikes us most about the head, is that which is also its weakest point, the colouring. Artists maintain that painting a sculpture is a mere daubing, since the fine points are already emphasised in the modelling. Apart from that, this bust was not intended to be a museum piece, but was meant for a sculptor's studio, and for him the colour was certainly of secondary importance. Consequently the painter did not take much trouble. We will not allow that to spoil our pleasure in the portrait however, and in the end we shall find that we should not even have liked the colour to be omitted.

The method by which Egyptian sculptors worked made it necessary that the outline of the figure which was to be cut from the block should be sketched on its rectangular sides. Thus the artist sees and fashions his work from the start from the perpendicular, directly from all four sides and from the top. That does not mean that he is indifferent to nuances of form or that we as observers should avoid an oblique view of Egyptian sculpture, in which indeed the delicacy of the modelling is particularly apparent. But we can best understand the construction of an Egyptian figure from observation of the plane surface of the front view and the profile. On these side views a peculiarity of the bust is immediately obvious, and that is the contrast between the heavy weight of the crown and the soaring slenderness of the supporting foundation. This contrast is above all apparent in the side view, through the forward pressure of the massive top portion and the supple but firm forward inclination of the neck. The almost rectangular encounter of both these forces at the nape of the neck is a successful hazard on the part of the sculptor. The artist relies on the cohesion of the stone to the utmost possible limit. Richard Jenner has shown in his above quoted description of the bust that the crown's dangerous overweight was somewhat reduced by the use of plaster. This experiment was obviously intentional on the part of the Egyptian sculptor. We can assume this, because in Egyptian sculpture a filling in the nape of the neck, which was to carry the weight of the crown, would otherwise be left in and that not only in cases where the equilibrium was hazardous. No critic could have raised objections to this. In the case of the king's bust found at the same place, the same sculptor Thutmose had left the neck supports standing.

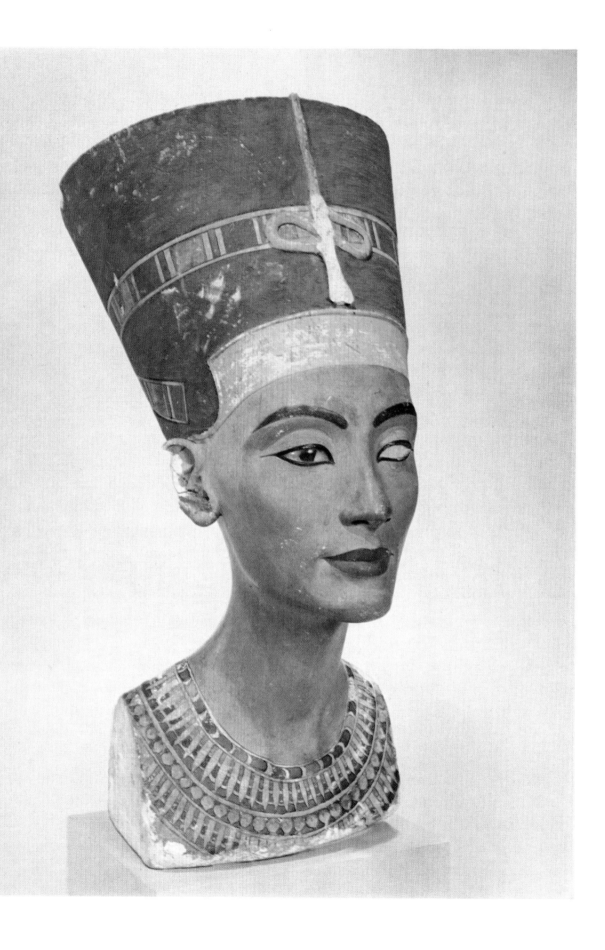

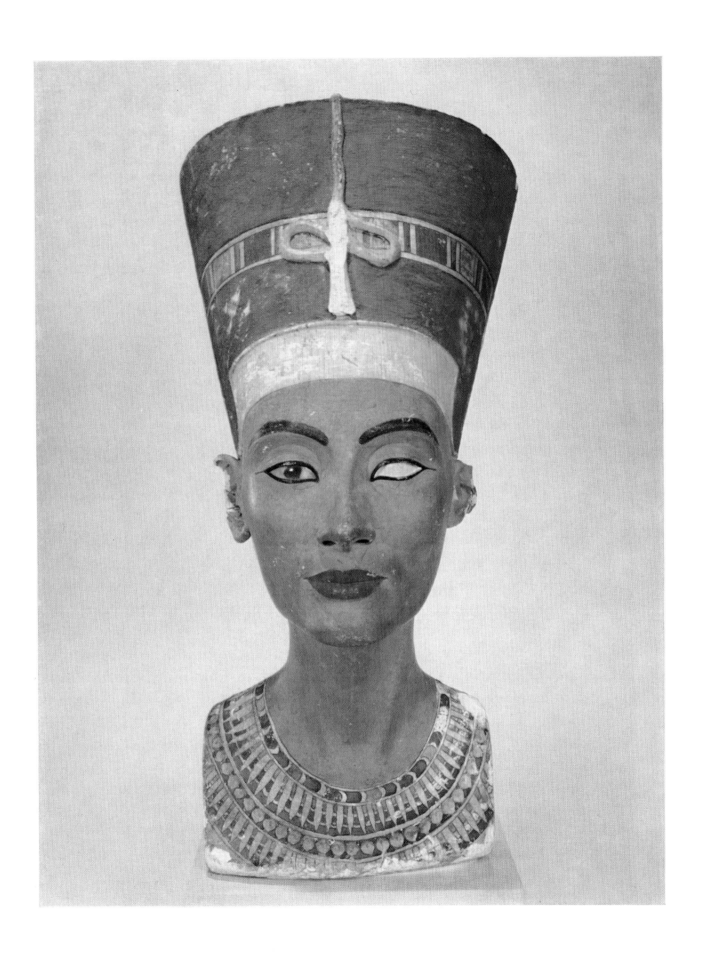

These two forces, from above and from below, straining forward towards one another, can be found again in the face. At the front, the bulk of the crown, lightened by the hair and the uraeus, is received by the headband, and by way of the eyebrows diverted over the bridge of the nose to the mouth, which is easily supported by the chin. On the other hand the lines at the corners of the mouth and nose are a continuation of the contours of the neck and its upward straining muscles, and carry them further upward, over the nose to the eyebrows, above which the headband presses. From the side the intersection of the two forces is evidenced by the sharp angle in the nape of the neck, since both crown and neck embrace the visage.

These examples can only serve to indicate in what ways a diversity of formative relations to the bust may be found, since such contemplation naturally leads to still greater insight. In this way the work of art will be more understandable from every point of view. The severe structure of the face, which at first sight may appear artificial, we now no longer attribute to the artist's whim. Rather we understand that it is a necessary attribute of the whole work. Indeed, a face like this, where such energy and force meet, must of necessity evidence a certain severity and can hardly belong to a young person. The delicate modelling of the cheeks not only gives the face a specially life-like impression, but we realize that it is essential to the expressive strength of this work of art. We can now better appreciate the colours, since they emphasise the moulded signification of the crown and neck ornament, the mouth and eyes. The bust is no longer for us the upper part of a human figure, which can be supplemented as desired, but rather a living image, complete in itself, and drawing on its own fountains of strength. It is not only a model for sculptor's apprentices, but is essentially a completely successful work of art.

In the Nofret Ete bust, as in the Amarna reliefs, we find the powerful and practically indivisible association of the portrait's component parts a means to contemplation and absorption. Compositions thus inspired by emotion or other influences are not typical of Egyptian art at all periods of her three thousand years history, but are a peculiarity of the style prevalent in the Amarna period and the following century.

Egyptian art, in the same way as art in the western hemisphere, has developed strongly in different phases, which have gradually became clear to us as typical of the period. Many experts prefer the serene candour and tranquil harmony of art in the pyramid era, to the thousand years younger Amarna art, sensitive and rich in associations.

A preference for one or the other period is entirely understandable and justified but the older should not be compared with the newer art of Amarna, with the result that this is found to be "un-Egyptian" and decadent. Such judgments do not do justice to the rich life that has always re-inspired Egyptian art and produced incomparable masterpieces.

About 1400 B.C. the kingdom of Egypt was at the height of its fame. From the first cataract of the Nile down to the Mediterranean the country had expanded to three times its size, stretching from the upper reaches of the Euphrates in Northern Syria far into the Sudan. A century and a half of conquests were at an end. The horizon of the world had widened enormously, fresh vistas were opened, and countless new ideas and untold riches, hitherto undreamed of, flowed into the land of Egypt.

This stream did not dry up even in the years of peace, but the struggle between the ancient Egyptian culture and the new ideas began then to present its problems. We can compare this age with our own modern world, in which, during the last four centuries, new discoveries and inventions have been made continually, and where the problems caused by them are only now being fully recognised. Questions concerning forms of government and society, international relations and humanity, theology and faith, demand a solution, and mankind is trying, with the help of reason, which has proved successful in other cases, to bring himself and the new world into accord.

In this period of mental activity the episode of Amarna in Central Egypt stands out as an apparent island of happiness and peace. King Akhenaton (1364–1347 B.C.) had turned away from the capital city of Thebes, her god Amun and the many political difficulties, and built himself a new residence, the pleasant garden city of Amarna, with its beautiful temples, palaces and houses. Within these wide boundaries the king realised his own solution of the problems of the times, a solution born of romantic longings and an overweening vanity, a transposition of the oldest form of government and economy into this spirit of the new age.

The chief god of the Egyptian faith, the Sun God Ra', was worshipped here, but deprived of all his traditional and accustomed myths and symbols, and named Aten, after his visible representation, the sun. Echnaton's famous hymn to the sun betrays a vehement piety, but also the King's inability to appreciate the divinity which lies beyond our tangible world.

The district of Amarna, with everything that lived and grew there, was consecrated for all time to the God as his sole possession, and thus also to the King, who is his son and counsellor on earth. Similarly, a thousand years earlier, the King, as God and Son of the Sun God, had been absolute master of Egypt. Echnaton's subjects, and all dwellers in Amarna, lived on what food and rewards the King vouchsafed them. Their personal privileges were reckoned as a gift of the King, so that a lawful existence outside the King's service was not conceivable. Man's conscience was to be no longer immediately responsible to the God, but to the King; even salvation after death depended upon the King's intervention with the Sun God. Echnaton was a great zealot and at the height of his power pursued and destroyed all noxious persons who did not subscribe to his ideas. The withering heat of this sun lasted from the sixth year of the King's reign until his death, and by that time Egypt was on the verge of a catastrophe. In Egyptian documents

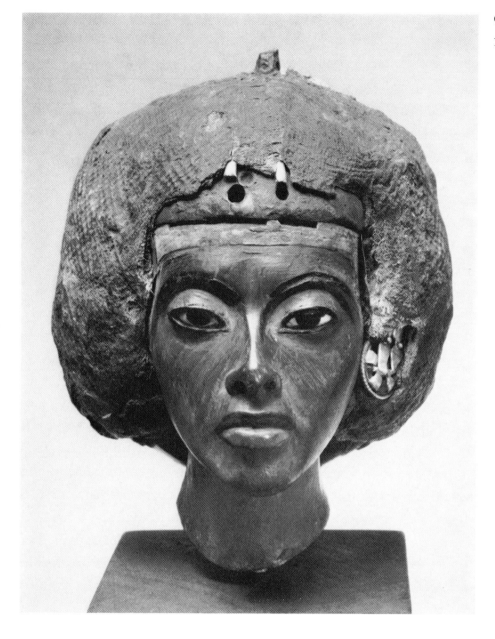

Queen Tiye,
Akhenaton's mother.
Yew, height 9.4 cm

of a later age Echnaton is only referred to as "that criminal of Amarna"; his name was not included in the list of kings.

This picture of Echnaton is not a speculative reconstruction, but is founded on unmistakable written testimonies, above all from his enthusiastic followers. But before this human, frightening background the City of the Sun pours forth her light. King Echnaton was an artistically gifted man. This is proved by his Hymn to the Sun and the fine arts which he fostered. Just as the romanticism of the community of Amarna and the rationalism of the Aten faith were revolutionary, so also was the naturalism of the new art, even though forerunners of this, as of every revolution, were discernible on all sides. At the beginning of his reign in Thebes

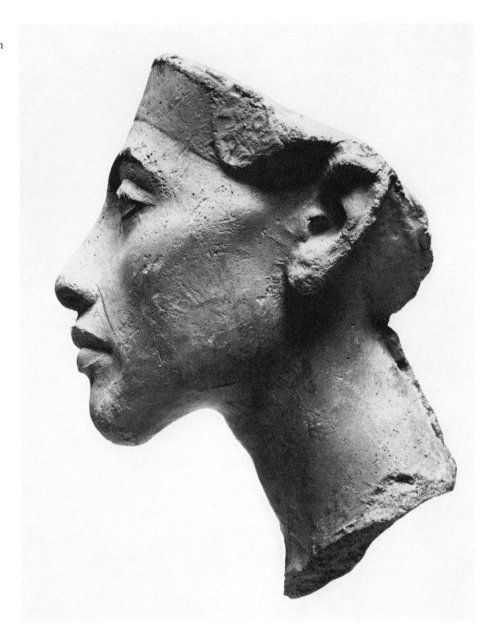

Echnaton gathered round him a group of artists, whose aim was to build up their work on a completely new foundation. In opposition to the artistic ideal which had hitherto served, they turned directly to nature herself, and searched out and over-emphasised the ugliness they found in reality. But after a few years this generation also found the way to the older line of development and by the application of the new means of expression gave the apparently outworn forms new and stronger life. The head of Nofret Ete signifies a climax in Egyptian art of the 15th and 14th centuries B.C. Its creator had certainly passed through the naturalistic phase of the early Amarna period, but in addition he was a master of the traditional sense of form.

Of Nofret Ete's personal life we know but few facts. She was called "theKing's Chief Consort,"

which shows that in the women's palace she was Echnaton's first wife. Her origin is not known to us. Her sister MutNedjmet is found in her train, and Ti, the "nurse of the King's Chief Consort NofretEte," is the wife of a court dignitary. We must conclude that there was no longer any connection between the Queen and her parents. Perhaps they were no longer living, or perhaps NofretEte, as a daughter of a foreign nobleman, had come to Egypt without her parents. At the time of the emigration to Amarna the royal couple had three daughters, and later six. The second eldest died as a young girl and was buried in Amarna. The parents' lament at their child's bier is touchingly portrayed on the walls of the sepulchre. Thus, probably, have experiences as mother, daughter and first lady of the royal harem influenced the character of this woman. Above all, however, she was the wife of Echnaton, who was certainly a difficult person, stubborn ungraciousness and fanatical emotion being united in his character. The name NofretEte means "Beauty is come;" perhaps her parents so expressed themselves at her birth, or the King, as he saw her for first time. But, an unusual proceeding in Amarna, Echnaton prefixed this happy name with an instructive one – Nofer Nefru Aten, that is, "Beautiful is the beauty of Aten." The King attached great importance to presenting his obviously happy family life to the people, an attitude that was not at all usual in Egypt. Murals in sepulchres and palaces, and altar pieces in houses often show the King's family, and on public occasions he was always accompanied by his wife, and generally also by his daughters.

The close of NofretEte's life, and that of her husband, are shrouded in darkness. A letter written at this time by an Egyptian royal widow to the King of Hethiter reveals political foresight. It is often attributed to NofretEte, but derives from her third daughter, the surviving wife of Tutanch Amun.

The bust was found in Amarna, in the house of the sculptor, who with reasonable, but not absolute certainty, may be called Thutmose. In a small room several medium sized works of stone and plaster were found. In addition to our head there was a similar but much damaged limestone bust of the King, and moulded in plaster, about twenty heads and faces which had then been re-touched; also a number of models, chiefly portions of such figures as it was intended to put together from coloured stone. These works of art may always have been kept in this room, or they may have been in other studios and were only collected here when Amarna was abandoned, – for the political wind had changed and these Amarna objects would only be a burden to the artist, supposing he survived the upheaval. Thus they were abandoned here.

Just as, thirteen years previously, Amarna, the City of the Sun, had arisen from nothing, so she just as swiftly disappeared when her inhabitants deserted her. The houses, made of unfired tiles, fell in, and the wind covered them with sand. The works of art in Thutmose's studio were ranged on shelves along the walls. These rotted and were eaten away by white ants, and gave way under their load. When this happened, the Queen's head, according to the excavator's representation, "turned a somersault and fell, comparatively lightly, on the top, flat surface of the wig, in the Nile mud deposit, which had fallen from the ceiling and walls and must already have covered the floor in the middle of the room."

From January 1911 Ludwig Borchardt had undertaken excavations for the Deutsche Orient-Gesellschaft in Amarna. During the third winter of the excavations, on 6th and 7th December, 1912, he and his collaborators uncovered that storeroom with its treasures. "Were I to describe this discovery here," he writes, "as it really took place, with its confusion, its surprises, its hopes and also its minor disappointments, the reader would certainly be as confused thereby as we were at the time, when we made notes in the studio, and had hardly got the particulars of one find on to paper before two further objects to be measured and noted were uncovered."

When, at the end of the winter, the regulation division of the objects found during the excavation was carried out between the Egyptian State Department of Antiquities and the Deutsche Orient-Gesellschaft, the sympathetic understanding of the Egyptian official representatives ensured that the discoveries in the model workshop were so divided that those works of art which were recognised as models or patterns were given in their entirety to the excavators. When this division was carried out the unique quality of the Nofret Ete head was apparently not sufficiently stressed by those concerned, which led to proceedings in the nineteen twenties, which were to have resulted in an exchange of the Nofret Ete for other works of art from the Cairo Museum. But it remained in possession of the Berlin Museum.

The bust as a form of art is but seldom found in Egyptian religious and burial services, but

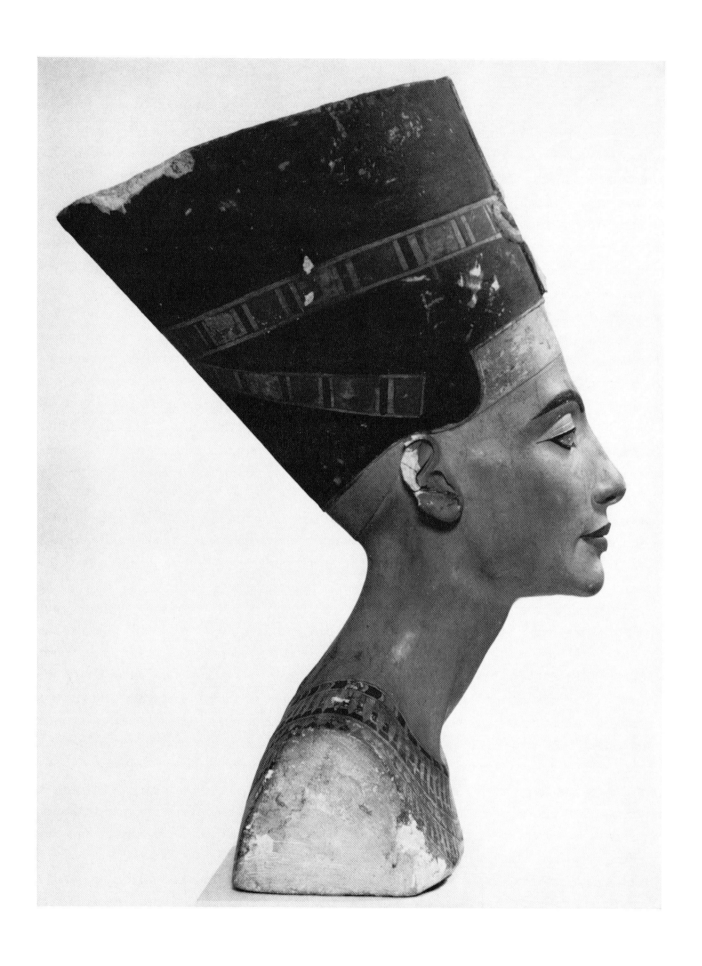

once that it is a portrait of a queen. In Amarna that could have been Nofret Ete, but could also have been her eldest daughter Merit Aton, wife of Smenchka Re, co-regent with Echnaton, or even her sister Anches Enpa Aton, wife of Tutanch Amun. The latter is well known to us from the portraits in Tutanch Amun's tomb, where she is shown as a young woman, whose gentle features in no way match those of this bust. There are no serviceable portraits of Merit Aton remaining, but when her husband died she was hardly twenty years old and so in her case too her age does not appear to tally with that evidenced by the bust. This is rather the portrait of an experienced woman on whose features life has left clear traces. So, from the first, we must assume that the bust in all probability represents Nofret Ete. This assumption is strengthened by comparison of the head with likenesses known to be hers. The family portrait, which shows Echnaton on the left and Nofret Ete on the right and on which their names are inscribed, certainly exaggerates and coarsens the physical characteristics, but the disposition of the brow, the powerful chin and the characteristic profile of the throat on its long neck, are points of comparison which confirm our assumption that bust is of Nofret Ete. Both these portraits also show the great dissimilarity to the distinctive and well-known features of Queen Teje, Echnaton's mother. Thus the remotest possibility that she might be the subject of our head is removed. With a good conscience we may therefore designate this as Nofret Ete's portrait.

Translated from the German by Kathleen Bauer, Berlin
Photographs by Jürgen Liepe from the files of the
 Staatliche Museen Preußischer Kulturbesitz
 Ägyptisches Museum Berlin
Printed in Germany by Universitätsdruckerei H. Stürtz AG, Würzburg
© 1973, by Staatliche Museen Preußischer Kulturbesitz
 Ägyptisches Museum Berlin
ISBN 3-7861-2231-8

 I. Edition 1953
 II. Edition 1958
III. Edition 1961
 IV. Edition 1968
 V. Revised Edition 1973
VI. Edition 1986